Wisdom

Andrew Zuckerman

Peace

PQ Blackwell in association with
Abrams, New York

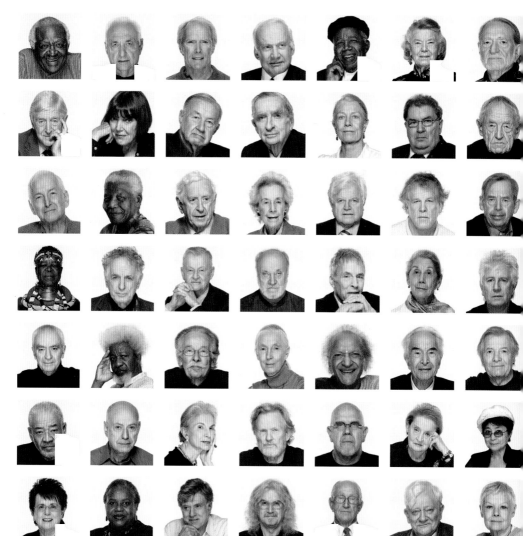

Wisdom

Andrew Zuckerman

Edited by Alex Vlack

Peace

Peace is an inside job.

Nick Nolte

The most important things in life are simple, like your breathing. And nobody's going to breathe dissonant sounds. You just breathe. Simple as that.

Be yourself and know that you count. And think about peace. Igniting peace is as simple as breathing. When you're imagining peace, you do understand that you can't kill somebody or you can't abuse somebody. You just imagine peace. You're in this trance. A beautiful trance of peace, of peaceness. That's what we're doing, all of us. We're trying to do that. We are each one of us an oasis for the world, and we have to realize that that's all we need to do. If you realize it, then it immediately happens. If we said, "I am dry, I'm just a desert," you immediately become a desert. You become what you want to become, what you think you want to be, what you think you are. It's very important. All of us have a super-god within us. You think about God: God is dead, God is in the church, God is wherever. No, God is in you. All you have to do is recognize that. A very simple example is a mother who is trying to save her child, who has this enormous power to move something that usually she couldn't move. We all have that power. Most people say, "That's so simplistic. Now she's getting so simple about her message. Is that because of her age?" And I think, "Wait a second, I've been studying minimalism since I was eighteen."

If anybody's thinking anything, it's going to affect us right away, and so all you have to do is just think about something positive, and it's going to affect the world. I have to tell you this funny story. I was in a car with a friend, and I suddenly started to want to eat a hamburger, and I don't eat meat. So I was thinking, "Why am I interested in eating a hamburger?" So I said, "I want a hamburger," and he said, "Oh, really?" He just gave me a dirty look. And, later, I found out that he was so madly in love with hamburgers that even when he goes to Paris, he orders a special hamburger. And that was sort of affecting me. It's just a silly story in a way, but we're all affected by each other.

Your oasis and my oasis are communicating. Water is very interesting. We are, what is it, ninety percent water? Inside, we have that beautiful, clean water. The water can become dirty, too, from our thoughts. So we have to keep cleaning the water with our good thoughts, for when my water and your water are responding to each other. You're water, I'm water. So there's nothing that we can hide from each other. While we're trying to hide from each other, our water's already communicating. It's so beautiful. That's why when we say, we are all one, yes, we *are* all one. We are containers of water. When we're fighting, our heartbeats are in unison. Can you imagine that? When we're trying to kill each other, the heartbeat's going boom, boom, boom, together.

Desmond Tutu

Each one of us can be an oasis of peace.

First of all it is important to know that each one of us can make a contribution. Too frequently we think we have to do spectacular things, and yet if we remembered that the sea is actually made up of drops of water, and each drop counts—each one of us can do our little bit where we are and it is those little bits that can come together and can almost overwhelm the world. And so it's important to try to be senders of peace. Each one of us can be an oasis of peace.

It is important, in dealing with anger, not to get upset with oneself. Sometimes you get angry with yourself because you got angry. Actually, anger is natural and it is something to be welcomed. Imagine someone seeing a child being abused and saying, "Oh well, this doesn't matter." You'd say there was something jolly well wrong with that person. There are things that must evoke our anger, to show that we care. It is what we do with that anger. If we direct the energy that the response evokes in us we can use it positively or we can use it in a destructive way.

One of the ways is saying, "Yes, I am angry that this person violated my right to freedom of expression, they didn't allow me to say what I wanted to say. I am angry, but I will redirect that anger into energy to do all I can to ensure that others don't have their rights violated." That is something we tend to forget in the heat of the moment: we should be careful not to depersonalize the other, we should not say the enemy is demonized. We should always be so mindful of the humanity of the other person and try to engage with that humanity. One of the ways in which they make soldiers find it easy to kill an enemy is to make out that the enemy is not really as human as other people, and you will usually have images of an enemy that denigrates them, that dehumanizes them. One of the most important things to remember is that even the person who has committed the most abominable atrocity still remains a child of God and has the capacity to become better. You are the best thing that God ever created and God doesn't create rubbish. You are the most wonderful human being. Remember that.

Generosity, compassion, gentleness, and caring are so much more powerful than their counterparts.

When you are sitting in a traffic jam, you are usually fuming and angry and upset and frustrated, and probably annoyed with a few of the drivers behaving very badly. Imagine if instead of wasting all of that energy negatively like that, we tried a more positive way: imagine yourself as an oasis of peace, and imagine there's ripples that move away from that center of peace and touch others. If there were more centers of that kind of calm and peace we would be surprised, because you'd discover that instead of your blood pressure rising as it usually does in a traffic jam, you'd breathe more deeply, more slowly, and you'd begin to have good thoughts. My grandson used to say, "Are you thinking good thoughts?" If he'd done something wrong and he was wondering whether he was going to get a slap, he'd say, "Granddad, are you thinking good thoughts?" He doesn't know just how close he was in fact to the truth. In thinking good thoughts, we begin to affect our attitudes, in a very real way. We affect our health as well, because the calmer you are, the better it is for your metabolism. When you begin to lose your temper, the body begins to get ready either for running away or for fighting, and so the metabolism changes, and you have things moving away from your stomach and rushing into your bloodstream, getting ready for running away or for fighting. In thinking good thoughts, the opposite happens: a placidity overcomes you. Generally most of us, when you are not rushed, when you are not frustrated, do tend to make better judgments than when you are rushed and upset.

You can't really go up and try to tell people to do things, it doesn't really work. Immediately their egos are confronted and their personalities and stuff like that, but if you live that way, if you live that way because it is a comfortable way for you to live, then that's an example and then people might try it.

We have great technology, we have great ability to handle things on the outside, and build cars, build roads and stuff, but we don't have any approach to what's on the inside of a human being. We have religions, but they are religions that are so steeped in traditions that everything has been put on the outside. Truly, the East is about finding who you are, spiritually inside. You don't even have to use the word "spiritual." It's about finding who you are. The reality of who you are. And when you reduce it down, it becomes that the miracle is life itself. It's not in heaven, it's right now. It's immediate and so it's living each moment. And that's what was brought into this country in the sixties, you know, "be here now," this whole idea of living for the moment, which was contrary to our culture, which talks about becoming something. When you have a little child and you look at that child and say that it has to become something…it's already something! It's already what it is. So this is what we have to learn from the East: all of this acceptance, and with the acceptance comes peace. And peace is an inside job. It exists somewhere inside. You can't negotiate peace, because a negotiation, by the simple fact of negotiation, means it's going to break down. Somebody's going to be dissatisfied. Peace is something that you find for yourself.

Crick, he wanted to answer two questions in his lifetime. One, "What are we made of?" and he discovered DNA. The next one he wanted to answer was, "What is consciousness?" So he was studying neurotransmission, the point of neurotransmission, and some of the technical ideas are that consciousness is nothing more than the neurotransmissions that are happening at this moment and that the brain is very plastic, and so consciousness is moving around, whatever we're thinking about, okay? But that's not really what can define consciousness. Consciousness is something you gain by experience and focusing on your own individual being. You know, trying to watch your own self being your self. Which is very frustrating, because then you have the observer and the observed, and you soon realize: are you the thought or the thinker? You are both; you are one thing. And that frustration leads you to surrender, and you surrender it and then that is what consciousness is about: surrendering and accepting. And then it becomes larger and larger and larger and larger. And you become more and more conscious of everything. There's nothing wrong with the mind, the mind is fine, it's a good tool and everything, it's just not everything. We have a thing in Western society that the mind is everything. Well, as an entity, as a being, the mind is rather petty. It's greedy, it's egotistical, short-sighted, and wrong most of the time. There's a space that's beyond all that, that once you recognize that the mind is like an organ, it's like your heart and it serves good functions but it's not everything. Then you begin to feel, where is this presence that

I am? Where do I reside in myself? Where am I? I've got a pool out here and it's ninety-eight degrees. I have an oxygen tank, medical oxygen tank, that I put in my nose. I breathe in oxygen, and then I take these rolls that float and I put them underneath my heels and one under my neck and one under my back, and then I have a silk cloth that I pull over the top of me and I cut a little hole, so I can breathe this oxygen through here, and the silk cloth keeps me warm because that part of my body's exposed. And I'm in this ninety-eight-degree temperature and I'm hooked up to a tube of oxygen, it's the umbilical cord, and as you float in that water you begin to feel a vague experience you've had before, and it's definitely a womb-like experience. Meditating and looking at the universe that way, looking up at the sky that way, you perceive that if you weren't there you wouldn't see it. So you are that. You are what you are seeing, there's no difference. You are it. So your awareness and your consciousness is everything, it's all of it and it's all forming into one. Everything is moving in a very peaceful way and you have a serenity. There is a true serenity that you can find. I am not able to stay there, because this is the world, I'm human, and we human beings have to drive on freeways and some guys think that it's "my lane," you know? Well, no, it's not "my lane," it's everybody's lane, but some people think it's "my lane" and how dare you pull into "my lane?" I have heard life described as being on a platform just the size of your feet on a pole three miles high; and that's what consciousness is, and awareness: how to stay on that pole three miles high on a platform like that.

Live in the right balance. If you live that way, you can't really go up and try to tell people to do things, it doesn't really work. Immediately their egos are confronted and their personalities and stuff like that, but if you live that way, if you live that way because it is a comfortable way for you to live, then that's an example and then people might try it. For example, I've got wells and I grow my own food, and when I get kids in here in their teenage years and they won't taste broccoli because they remember it from school, that mushy stuff from a can, it's horrible, and when I break off a piece off a broccoli and I say, "Here, taste this," they go, "No, no!" I take a stalk of broccoli and then I peel off the skin and the pulp on the inside is so sweet, it's so delicious that when I give it to them they say, "This is broccoli?" I say, "Yeah, this is what broccoli really tastes like." You can change minds that way.

Alan Arkin

We're a part of the environment.
We are one aspect of the environment.
We're not separate from it or better than it.

What can one person do? My focus, my belief is that if people clean up their own act spiritually, for want of a better term, you automatically have a profound effect on the world around you. I think it's a natural by-product of working on yourself, finding out who you are, what your real needs are (as opposed to the things you just want)—and when you are living according to your real needs, it automatically translates into your cleaning up the environment. It's not about just policing your own area, because that can just be about assuaging your guilt, or allowing yourself to get off the hook. "Look at me, I'm doing something for the environment, I threw out three things..." It's not something to be prideful about. Rather, it's something to have to do because it's a bedrock necessary. It's necessary for the world and my own growth, my own simplicity. We've got to stop being so prideful about the fact that we're doing something that the world needs. It's not a matter of pride, it's a matter of dire necessity, internally and externally.

John Hume

Differences are the essence of humanity. There are not two human beings who are the same.

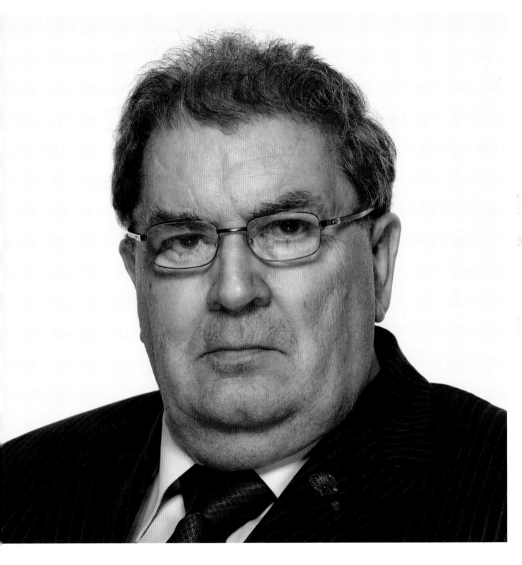

You'll find that the three principles at the heart of the European Union are the same three principles at the heart of the Good Friday Agreement in Northern Ireland. What are they?

Principle number one of the European Union: respect for difference. When you look at conflict, no matter where it exists, what's it about? It's about difference. Difference of race, religion, or nationality. And the answer to difference is to respect it, not to fight about it, because differences are the essence of humanity. There are not two human beings who are the same.

The second principle is to create institutions that respect those differences. When you look at the European Union, all countries are there. European Commission, all countries are there. European Parliament, all countries are there.

And the third principle: instead of warring or fighting with one another, work together toward common interests. Or, as I would put it, spill their sweat and not their blood. The countries of Europe work together in the socio-economic development of Europe. And that has broken down the barriers of the past, and a new Europe has evolved, and is still evolving.

And if you look at the three principles at the heart of the Good Friday Agreement in Northern Ireland, you'll find the same three principles. Principle number one: respect for difference. The identities of both communities are fully respected in the Good Friday Agreement. Principle number two: institutions that respect difference. The Assembly of Northern Ireland is elected by proportional voting, which ensures that all sections of the people are fully represented. And then the Assembly proportionally elects the Government of Northern Ireland, and that ensures that all sections of the people are represented in government. And then the third principle: they are then working together in their common interests, spilling their sweat and not their blood. That has now begun. In a generation or two there will be a completely new Ireland, because as they work together in spilling their sweat and not their blood, we will break down the barriers of the past and a new Ireland will evolve, based on total respect for difference, and with total lasting peace.

We're much closer together in the world today than we ever were in the past. Given that it is a much smaller world, we are in a stronger position to shape that world. As we enter the new century, and a new millennium, let us create a world in which there is no longer any war or any conflict.

One way of doing that is to draw our lessons from the European Union. The European Union is the best example in the history of the world of conflict resolution. When you look at the century that has just passed—two world wars, millions of human beings slaughtered—who could have thought that in the second half of that century those countries would all be united? There's the best example of conflict resolution and the principles should be studied by other areas, and sent to any area of conflict.

When I was first elected to the European Parliament, I went for a walk. I crossed a bridge in Strasbourg, in France, to Kehl in Germany, and I stopped, and I meditated. I said, "There's France, there's Germany." If I had stood on that bridge thirty years ago, at the end of the Second World War, the worst half-century in the history of the world, and if I'd said, "Don't worry, in thirty years' time there will be a united Europe," they would have sent me to a psychiatrist. But it has happened.

Chinua Achebe

The kind of damage colonial rule does is that you no longer have the ability to rule yourself. If you walk in and take over someone's land and even his person, that victim will not be able, at short notice, to take over. You say, "Okay, I give you independence." That person has already lost the habit of independence over years, over decades, sometimes over centuries. So it's a question of beginning to reinvent yourself the way your ancestors must have done thousands of years ago, because they learned to rule themselves and organize themselves. We don't have it. So it's not even an option to say, "Okay, I leave, you take over." It's going to go on for a very long time.

We must learn about ourselves, about our past. It's a matter of schooling, but not the kind of schooling that colonial rule brought: training for somebody else's advantage. This new education is going to be for your own good, and in the end, for the good of the world. Because we are all in it, you know? We're worse hit than the invaders, but the invaders are just as helpless to save themselves as their victims. The emphasis must, of course, stay with the colonized people. Not their colonizers. If they can work together to bring about a different future, that would be wonderful. But nothing is guaranteed in this situation, nothing is promised. Even the language doesn't exist. If you read the poetry, for instance, of colonized Africa, let's take a piece from Senghor: "They call us cottonheads and coffee men and oily men. They call us men of death. But we are the men of dance whose feet only gain power when they beat the hard soil." It's not a very friendly conversation and this is a very gentle poem. You'll find a poem that begins, "The white man killed my father/my father was strong. The white man raped my mother/my mother was beautiful. The white man killed my brother in the noonday heat and then turning to me he said, 'Boy, a drink, a chair, a napkin'." You see, the chances of easy and pleasant discussion are very limited.

The difference between European colonialism in Africa and American imperialism in the Middle East is the British were there for a very long time and intended to be there forever. They also had to use the local talent, not only because they thought it was good to train the natives, they'd also taken on more than they could chew. They were rather greedy. A quarter of the world was British, and so there was no way they could manage this themselves. They

had young graduates of Cambridge and Oxford going out to be administrative officers. Well, there were not enough of them, not even to run a place like Nigeria, not to talk of India. So they were forced to bring in the natives. "Okay, you can do this as you've always done it, but we will be watching just to make sure you don't misbehave." That kind of thing. So it was forced on them to introduce what they call "indirect rule." Now, the Americans have not taken on as much as the British had and have not had the experience, and they have a kind of history that praises their own history profoundly, so that it's difficult to conceive of the evil that they might be perpetrating when they go out with the excuse that they are trying to help. And so I would say the difference is, first, lack of experience, second, lack of humility.

The American clearly believes that he has the best system in the world, and that nobody should be looking for anything else. But that's not the way it is.

What worries me maybe more than anything else in Africa is the inability of the leaders to understand that no one person has the answers to everything. No leader, no single leader has the ability to run a country, a huge country like Nigeria, like Congo, year after year after year. I thought the example of Mandela in South Africa saying, "After four years, someone else," would have been received by leadership throughout Africa. But it hasn't. Nobody heard that message. And so you have people who are in power for twenty years or people who had four years and they want another four or five.

We have to move away from this idea that only "me" can do it, because that's not true.

Rupert Neudeck

A single person can convince a whole society.

There is something in the hearts of the people, and in my heart, which is tangible, which cannot be communicated across great distances. From the Bible, we have this wonderful story of someone who was hurt, who had been attacked on the way from Jericho to Jerusalem. And there were people going by, who were seen as "competent" people for relief and for support and assistance, and they were not touching this man. Only the one who did not seem capable of helping him was able to help. We are always able to do something, and we are always able to be touched. This is compassion. This is sympathy. This is something you can't deny in yourself.

In my life, in my activities, I was becoming aware of the very ambiguous position of prudence and intelligence—especially of academic and professional intelligence. Expertise; experts; knowledge. If we always follow academic knowledge and professional knowledge, we will never arrive at the idea of going into the sea to save people. There are many arguments against it, many very good arguments: it's too risky; the sea law jurisdiction is not defined; we are going into an area controlled by the Vietnamese Navy; we have to go into an area where there are pirates. It's dangerous. All arguments are against this activity. But then there is the question of whether you will do it. This is quite another question. That has nothing to do with experts. It has nothing to do with so-called competent people.

I was always aware of this: don't ask the experts. My government asked me whether I had asked the "competent" organization for what I wanted to do. Thirty years ago, I didn't know that there was an organization, but there was one. Everywhere in the world we have "competent" organizations. In Geneva, there was a United Nations High Commissioner for Refugees, and I went there. This man was "competent" for my request. And after I attacked him, when I wrote, "Are you doing anything? You have the competence as a world organization under the umbrella of the United Nations. What are you doing there?" he told me, "No, this is very, very difficult. We haven't yet taken up this case, and we can't go beyond the border to the other side to interview the refugees. How should we do it, interview people on the sea? We cannot put a table there!" That was before I knew that non-governmental activities go straight to the problems of people in distress, rather than to the "competent" people.

I never felt fear. It was always full confidence that we were doing something very good and that we, in a way, were protected. I never felt in danger myself. As a journalist, you see all these people in a much worse situation than yourself. Me, I can escape. I always have my ticket, my return ticket. They have to stay there. So that absorbs all fear. I always felt myself in a privileged position as someone with white skin with a good passport. I was always in a better situation. My government will pull me out of there in case something goes wrong. They have the obligation, and they will do it. But besides that, I always felt protected because I believed in it.

When I was five years old, I went with my mother to sail on a big white ship. And an uncle of mine came to my mother, shouting loudly, "Why are you late, one hour late?" We missed the ship. And then we heard that this ship was torpedoed by three torpedoes by the Red Navy in the Baltic Sea, and more than nine thousand people were dying, drowning. So because we were one hour late, we had survived. I'm here with you in this interview because I was one hour too late. So this feeling came to me when I was in the South China Sea—that I had to do something where people were drowning in the sea. Because I was myself almost in the same situation, but I had been saved. And we Germans, we're all safe. And no one in the world has to care for us, because we did the war. We did the Holocaust. We did all this. There is no justification, no reasonable justification, for that. So now we have to give. Our country is now in a privileged situation, with our society, our Constitution, our economy. Now we have to give back. It's an obligation, a good obligation, an obligation which makes you happy, not something that is forced.

A single person can convince a whole society. As a single person on the train from Paris to Cologne, on 3 February 1979, I was looking around myself, thinking, how could I convince my society? I wrote then to Heinrich Böll, who was known in our society, who was popular—I wrote him a letter on the train. Two days later he phoned me, and said, "Yes, Neudeck, we have to do this. We have to do it together. I will do it with you." So this was two. One becomes two, and then it grows. Anyone can do

something important to mankind. You never have to be limited by being alone. That's just your imagination. You're always bonded to others—in your profession, in your family, in your hometown, in the train, in the plane, wherever. We are living in a quite exciting time because it's easier now to work with others and to convince and to inform others. Anyone has the Internet now. You can make your own newspaper if you like. You, that single person. Possibility is bigger than reality.

Traditionally, we grow up to learn that we should be ordinary citizens who would like to have a career. This is a limitation in itself. A career is good, but if it is the only thing you are looking forward to, then it is bad. There's a big obstacle in ourselves because of the conditions of life, of the framework of our society. Obstacle number one is insurance. If you are always looking for security in money, then you are in a very bad situation. The framework of a good society, of a wealthy society, is sometimes a hindrance for doing something for others. That is not an argument against wealth and against a good society and against security. We should use these things, and we should be happy if we can help others, for the future of our children, for the whole world, and all mankind.

When I come back from Zimbabwe, from Rwanda, people say, "Oh, we have heard of these sicknesses, of these epidemics, of cholera and of tuberculosis and of malaria. How do you survive?" I can only laugh, because I have a wonderful life with these people, it's wonderful to share this life with them; but

we always think that we have to protect ourselves against something, an enemy sickness, an epidemic.

It's good that we have such good food, such good accommodation, good transportation, that we're safe—this is all good. There is nothing bad in it. But we would like to have it not only for us—that's egocentric and egoistic. And this is one of the biggest reasons for humanitarian work in the world. We have to push the movements which are already started by conferences and the UN, with the millennium goals and so on and so forth. We have to bring a kind of avant-garde—people who are jumping out of their conditions for a time, to show people in their society that something more is possible.

I can't think of an activity I've had to do alone. You have to live bonded to others. When my wife and I got married and when we had our first child, we were not aware of the work I was about to do. It happened suddenly. But we felt that the humanitarian work supported our life as a couple. Women, in a society like ours, feel underestimated when they only take care of their children and don't keep their jobs. And my wife decided to leave her job for the children when they were growing up. But then we were in this position where she could do the same full-time job inside our organization, and she could do it with the children, who were always with us. I always thought of that as a model for a normal society like ours, that people can do a lot being together when they are pushing together, putting all their energies together synergistically toward work.

We are not alone in this world, in humanitarian work. Besides the Church, who have a process and procedure for coming out with saints, we all have in our life our secular saints, who are sometimes more important for our lives than any other saint. For me, one of these most important saints was and is and will always be Nelson Mandela. He came out of jail as someone who was supposed to get revenge, as most people would expect. And he did the contrary. So for me he represents the biblical message. No one shows me the meaning of the New Testament like Mandela.

Religion can be used for ill or good.

People need to have respect for each other's faith. Religion can be used for ill or good. Archbishop Desmond Tutu said an amazing thing. He said religion is like a knife: you can either use it to stick into somebody's back or slice a piece of bread.

It is essential to care about human rights—that, ultimately, is the basis of our existence. The responsibility to protect does trump sovereignty. If a sovereign does not take care of his or her people, the international community has a responsibility to protect.

Frederik Bolkestein

We must have a tolerance of differences.

To achieve peace, the most important thing is to know what motivates your enemy. Dealing with the manifestations of his animosity is important, but it may not be sufficient. You have to understand the background of his animosity. If you don't, it may return, and perhaps even in a worse way. That is not always possible. Some conflicts cannot be resolved. We in the West are taught to believe that conflicts can be resolved, that problems can be solved. But sometimes that is not the case. And then you have to live with it. For people of all backgrounds to coexist, we must have tolerance of what motivates other people. We have many different cultures—some are dominant, some are not. They're all important. We must have a tolerance of differences. The world consists of many different peoples and there is not any particular culture that should be dominant.

I was born in 1933. When I went to university the Cold War was in full swing. I studied various subjects, and at the end of it, I thought about writing a doctoral thesis on the subject of the anti-democratic intellectual. Now, I didn't. I went to Mombasa in Africa to sell oil, which was most probably a wise choice because at least I learned a trade, I learned a business. The whole Cold War controversy between the West and the Soviet Union is something that I very much lived with. I never expected the Soviet Union to collapse; or rather for Communism to collapse and the Soviet Union in its wake. Let me add that it is not true, in my view, that President Reagan caused the demise of the Soviet Union. The Soviet Union collapsed because of the empty words and the empty shops.

Dave Brubeck

You have to be taught to hate.

I remember my wife saying, "Look how the Nazis taught the Nazi youth movement. We could have taught the love movement." Someday we might get there if we really tried and really educated the youth of the world. You have to be taught to hate.

I've just finished a piece called "The Commandments." I wanted to write that piece when I was in the Battle of the Bulge because of all the death going on. I was raised with the idea of the commandment, "Thou shalt not kill." I thought, I've got to write a piece of music on this if I get out of here some way. And it took me till last year to write it. I wanted to find what would tie humanity together with this kind of thought and the center of one of my first oratorios was, "Love your enemies. Do good to those that hate you." I wanted to see if the Koran had anything like that and they told me, some people that knew about the Koran, that they thought maybe there was, but they didn't know where. I got a phone call saying, "We finally found what you're looking for." It says, "We must follow the laws of Moses." Well, what are the laws of Moses? They're the commandments. Then we looked up what Buddha said: "The crowning enlightenment is to love your enemy." So, here we are, really in a struggle for the world to survive, and we've had the basic laws in most of the great religions that would save us. It's so simple. We used a quote from Martin Luther King, Jr. in one of my works that I did with my wife. "We must live together as brothers or die together as fools." All the great minds come up with something like that. Even some that don't believe in religion come around to something like, "We were all created from one wonderful mistake that came out of the ocean in some way." We are all tied back to that first man, so we are all together. We are all brothers and sisters and we just have to have education. It doesn't have to be religious. All forms of education that point to human survival, we've got to study.

Zbigniew Brzezinski

To resolve conflict, excessive ambitions and one's own fears and aspirations must be sacrificed.

One has to understand what the enemy is all about: the enemy's history, the enemy's culture, the enemy's aspirations. If you understand these well, you can perhaps move towards peace.

For people of different faiths to coexist, it's going to take maturity, wisdom, and patience. All of which come, eventually, with tolerance. And it's a process of time.

I did not expect the Soviet Union to collapse so quickly and I didn't expect America, as the only global superpower in the wake of the Soviet collapse, to make so many basic mistakes so soon thereafter.

Today, with America being a beleaguered global power, in part because of its own mistakes, it is absolutely essential that the American democracy refocuses its concerns towards global issues and does not approach its own specific problems on the basis of, to some extent, self-induced fear.

Only history is going to show what really mattered here.

During World War Two, you have to remember the country felt extremely vulnerable. The country had never been attacked on its soil. It became a big shock, a big wakeup call. But it also became a big wakeup call to a different kind of people than we are now. Everybody talks about now being sort of a "Me Generation." Everybody is more worried about their 401(k) than what's really going on in the rest of the world. I guess there was an element of that before World War Two. We closed our eyes to a lot of things that were going on, with Hitler, and the Japanese advancing into Asia. World War Two was a bunch of skinny kids out of the Depression, and they just barely got through that, and then said, "Now we gotta go to war." People just got with it. They got with it and they didn't question all the morality and stuff. Later on, as other wars became more political, wars like Korea and Vietnam, people got calloused towards it. They sort of lost their motivation for it. And Americans don't have a long attention span anyway. When they went into Iraq, I remember thinking at the time, I said, "Boy, they better hire that Republican Guard, pay them double and get them going right away." Because a couple weeks and everybody goes off on a different tangent. And what would happen if we had a World War Two parallel situation today remains to be seen. One of the big fears is, do we have that kind of resolve to complete that kind of a task? I don't know. We probably would if we had to, but the big question today is, "Do we have to? Can we let it go?" The long range thing, nobody knows.

Nadine Gordimer

We have not been given credit for what has been achieved after the decades and decades, several hundred years, of total racism. People think that racism began at the end of the forties, when "apartheid" was coined as a word and it became an official part of the government. But it started in 1652 when Yonven Rebeck, of the Dutch East India Company, landed at the Cape and started using it as a refreshment station for people from Holland going on their way to India. The Dutch East India Company was the very beginning of all international companies. Then the first thing that happened was that a fence was put up round the residence, to keep out the indigenous people, the black people. So we've had racism with us through all the different dispensations of government. Way up until we ended and voted for the first time all together, in 1994. But it's fourteen years now, isn't it? Thirteen or fourteen years since then. So how can we be judged that we haven't got full employment for everybody, we haven't got everybody housed decently, we haven't got our educational standard in the rural schools, and so on. We've had less than a generation to do it. So give us some credit for that. You people in the Western world have had hundreds of years and still haven't got a perfect democracy, and have still got a lot of poor people in many countries. That's a very important thing to remember.

Garret FitzGerald

You need to understand your own history and the history of the country you're dealing with. History often provides the obstacles to a solution, and therefore it has to be understood in the first instance. You must understand the obstacle before you can get rid of it.

Empathy is the key

o all relationships.

The first thing in negotiation is to understand where the person you're negotiating with is coming from. What are their interests, their concerns? Why are they taking up that position? Unless you understand that, it would be very hard to get agreement; and that involves empathy with the other side. Without empathy there would be misunderstandings and hostility. Empathy between countries is difficult because large countries find it very hard to understand and empathize with small ones. Small ones, on the other hand, to survive, have to empathize with and understand larger countries. Sometimes the difficulty is to get the larger partner to understand your point of view even if you can understand theirs.

In politics there's always a question of compromise. If a politician always does the right thing, regardless of consequences, he or she won't survive long. On the other hand, if they do the popular thing all the time, there's no point in them being there. So the nature of politics is compromise. But always with a view to doing enough useful things to justify the compromises you have to undertake in order to stay there and get something useful done. And that is the key to it. I think perhaps people who are not in politics don't understand this issue of compromise. Because politicians must compromise to survive, they are downgraded morally by people outside who don't face these issues. Politics involves a huge increase in the kind of moral dilemmas you

meet. In your own life, you meet moral dilemmas, usually more between a greater or lesser good, or a greater or lesser evil. In politics, the number of decisions you have to make which require a moral compass is enlarged, which makes it the most exciting career you can have.

For people of different religions to coexist, they must avoid too much certainty. Religion is enormously valuable and has formed our whole civilization, but there are people whose involvement in religion is because they want certainty, and that certainty sometimes makes them so sure of themselves they can be very negative about other people. Faith can be very positive, but it can turn negative. The important thing is that you have to understand the other person's point of view, why they differ. Empathy is the key to all relationships, and not to allow your own beliefs to try and dominate other people's beliefs.

My mother was a Northern Protestant and my father was an Irish London Catholic. My mother was the more extreme of the two, and when we received independence she opposed the government in which her husband, my father, was the Minister of External Affairs. I was born later, after it had happened, but it meant that I recognize the tensions that can exist and the need for people to surmount those tensions and to learn to work with others they don't necessarily agree with.

Federico Mayor Zaragoza

We are living in a culture of war. Let us now have a culture of peace.

Sovereignty is not an excuse to act against human rights. I saw in Cambodia what had been done during only four years, from 1975 to 1979. In a country of eight million people, twenty-five percent of the citizens were killed and everyone stood by and said, "Sovereignty." What happened in Rwanda? The same thing exactly. We must now come back to the United Nations and its "We the peoples." When this happens, the United Nations, on behalf of all the other nations, must say no. We can't enter there and ask for a democracy, but we must immediately put the blue helmets there to say, "You cannot do what you are doing." And then you must think of a way to consult with the people.

For many centuries, we have been behaving in the framework of a culture of war. For over two thousand years we have said that if you wish for peace, prepare for war. We have been in a male society, therefore we immediately use our muscles instead of our capacities for thought. This was the very core of the proposals made by a very distinguished, very wise President of the United States, Franklin Roosevelt. At the end of the Second World War when the United Nations was founded, it began by saying, "We the peoples have resolved to save the succeeding generations from the discords of war." What does this mean? That we have decided now to build peace, not to prepare war. But, as often happens, because there is an immense machinery for war—an immense industry of weapons—here we are again; as happened with President Wilson in the year 1919, when we started again preparing for war. And we have war. When I was elected Director-General of UNESCO, I said, "Well now, what I must do is to put into practice the original mission of UNESCO that says that we must build the defenses of peace in the minds of men." And they said, "What is a very

short expression of peace?" The answer: a culture of peace. We are living in a culture of war. Let us now have a culture of peace. Let us be prepared for a culture of peace. Instead of always thinking about how we can be stronger, let us now think about how we can be wiser. We will always have conflict. But we must prepare ourselves for dialogue, for understanding, for conciliation—instead of the imposition of violence.

The path toward peace is much easier than the path toward war and confrontation. We have a lot of good examples, but let me choose one. In June 1963, just some months before President Kennedy was assassinated, he said, "I am told that disarmament is impossible. It's not true. I am told that peace is unfeasible. It's not true. There is no challenge that is beyond the human creative capacity." This is what I think. This is what I considered when I was in UNESCO. We have the capacity to create, to invent. This is the monument that we must safeguard. Solutions are easier than we can imagine; because what we must do is to listen. What we must do is to create a permanent dialogue. And we must accept all views, all opinions. Sometimes I have spoken with leaders that are little dictators or very big dictators, and they say, "Yes, but provided that those that are in the dialogue say exactly what I would like." No, no, no. You must accept that one or two or three or many people in one dialogue may have an opinion that is exactly opposite to yours. And you must accept all. Only one thing is unacceptable: lying. All the citizens of the world have seen that the leaders of the world, unfortunately, were lying because they wanted war. They wanted to invade Iraq and they were lying. We must put that aside. The way toward peace is easier than we can imagine, provided that we are able to invent peace, that we are able to behave according to our reflection. Very often we

are spectators of what happens. We are resignated spectators. We are there only as receptors. And we must be actors of our lives. This is the most important mission you can have in the world.

At the end of the eighties, we were happy because suddenly the Cold War was ending; there was agreement between the United States and USSR to end the armament race. And the wall fell down in Berlin. It was the two-hundredth anniversary of the Declaration of the Rights of the Citizen from the French Revolution. It was all full of good hope, that now we will have the dividends of peace. No more investing in armament. Now will finally be peace. And at this moment a very, very bad decision was made. They said, "Now the economy will be guided by the market." It was a terrible mistake. The market can be very, very good for enterprises, for transactions, trade. But social justice, freedom, equality, solidarity—these are values that must guide us. These are the important values to promote; because while entrepreneurs know how to do business, it must be regulated. That's the responsibility of the State. We must not forget that the State must be the voice of the citizens in a democratic context. The great poet Antonio Machado has a little verse that says, "You cannot make any kind of communion between values and prices." And we did.

It is said that the Catalans know how to count very well because we count even when we dance the *sardana*. As a Catalan, I know very well that the market does not exist. The market is an association of all the people that are in commercial transactions, and to say that from now on we will be guided by the market—Lord, what a disaster. And now we are in a very big crisis. But this crisis is not only a financial crisis, it is an ethical crisis. It's a crisis of moral values,

of human rights. It is an environmental crisis, it is a food crisis. At this moment we are investing three billion dollars per day in armament while sixty thousand human beings die every day—thirty-five thousand of whom are children—of hunger. How can we have a global consciousness if we know that every day there is this kind of silent genocide? How can we be in our very privileged part of the world, of this global village, as it has been called, when most of the people living in the world are, at the same time, in such conditions?

We were told some years ago that there is no money to fight poverty. "We're sorry, but there is no money for those that are dying." There is no money for food, for the more than one billion people in the world that need food, for those that are dying every day in Africa of AIDS. I have a foundation for AIDS in Africa with Professor Luc Montagnier. We need to collect a little money because there is no money for the AIDS fund in the United Nations, for example. But then suddenly, now it appears that there are billions and billions, eight hundred and twenty billion dollars. What is this? There are many vulnerable sectors of the society, worldwide, that really are living in absolutely inhuman conditions. Now is the moment to change that. For this reason I have admired the way in which President Barack Obama has persuaded the United States, after a very bad administration, about change. And I am sure that it is for this that he inspired so many young people. Young people know that things are not going well, that we are going down instead of going up. And when a young person talks about change, this is very good because this gives you a new kind of hope. This was the second word. The first word: change. The second: hope. Third, as Kennedy said in 1963: we can. We can invent our

future. We can find solutions for everything. If the impossibles of yesterday are today's possibles, we can make today's impossibles feasible in the future. If we were having this meeting in the year 1990 and I were telling you that soon South Africa will have a black president, you would have told me, "No, it's impossible. It isn't feasible." And this was the case. Why? Because Nelson Mandela had this fantastic capacity to make a complete change. After being in prison for twenty-seven years what would be the normal reaction? The normal reaction would to be leave the prison and say, "Now I am going for vengeance. I am going to kill whatever I can." But he left the prison with open arms, saying, "Let us now arrive, too." And the thing changed. What appeared to be impossible was feasible. And what happened with Gorbachev in the USSR? You remember the USSR? Remember all what was happening? And then suddenly a man appears on television—just by utilizing the media he was able to accomplish this fantastic change in the USSR without a single drop of blood. Fantastic. Why? Because he was inventing a new Russia. He was inventing a new way. Finally, with a lot of imagination, with a lot of creativity, he was breaking down the terrible system that came before and created a new one. I have a lot of confidence in human beings. I am not optimistic. I do not like to be told that I am optimistic. Because you know what they say; they say that an optimist is an ill-informed pessimist. And I am not an optimist, but I am full of hope, precisely because I know very well the distinctive capacities of human beings.

In the seventies, it was said, "The new name of peace is development. Let us eradicate poverty. Let us take into account that all are human beings." And then it was said that the rich countries will give a grant equivalent to 0.7 percent of their GNP. Well now, look, again, as a Catalan, if I give you 0.7 percent, I have 99.3 percent in my pocket. It's very reasonable. This has not been done. Those that were the most powerful, the richest countries of the world, who associated themselves in the G7, G8, today they are having meetings. Meetings to do what? They have been unable to make progress in the market economy. They have been unable to foresee what was coming and therefore to avoid it. We need to restore the United Nations with the resources it needs—personal, technical, financial, and the military forces when they are needed.

When I was fifteen or sixteen years old, my mother told me that the only way to be happy is to feel yourself independent, to realize that you are doing what you consider you must do, that you are acting according to your own will. Never accept what you think is unacceptable. I can accept that it's difficult for many people because they are full of fear. But I must tell you that there is a lot of possibility for change today. Because until now participation was very difficult. We could participate when we went to vote and sometimes in some public opinion polls. But it was very difficult to demonstrate; sometimes very dangerous, too. Now, for the first time in history, and young people know this very well, we have the possibility of non-presidential participation. This will change the democracy that we have today. Because today, everything is presidential campaigns: voting, a lot of flags, et cetera. Now, with SMS, with mobile phones, with the Internet—in perhaps ten years there will be a radical change in the possibility of participation. My advice is to not remain silent anymore. I tell this to the academic and scientific community to whom I belong. Sincerely, the scientists have been too silent too often.

Malcolm Fraser

We begin to understand a person's wisdom based on what they do, what they stand for.

If you take some examples out of recent times, there are people who train to believe in the rule of law, due process, equal application of the law to all people regardless of race, color, religion; and then you look at what they do and you find they don't mean a word of it. So you don't really think very much of that person who's prepared to espouse a principle but then, when it's politically expedient, just casts it aside. Since the war on terror began there have been people in both the United States and Australia who have been prepared to say, "Of course I believe in the rule of law, but it doesn't apply to him, or it doesn't apply to them because they're awful people, beyond the pale, beyond the reach of the law." They're not wise, they're not sensible. If you believe in the law, it applies to everyone. Once you say it doesn't apply to one person or to a group of people, you are really saying, "I don't believe in the rule of law." It's very easy for people to describe themselves in the best manner, as upright and proper people; but their actions can belie that, every day, every week, every year. I sometimes see the wheel going around in relation to these things. I've experienced a little bit, I've read a little bit more history, and the sorts of things that are said now *used* to be said in Australia. For example, "Well, today Muslims aren't really Australians, because their first duty is to the Prophet." In my father's time people said that of Roman Catholics: "They're not really Australians, their first duty is to the Pope." Now nobody believes

that any more, but for a number of reasons that were complex and difficult, that involved bigotry and hatred—total lack of reason—people believed it of Catholics, fifty, sixty, seventy years ago, and it created a sourness, a bitterness in this country that endured and amongst older people is not entirely dead. And families were divided on it: if a boy wanted to marry a Catholic girl or the other way round the world would fall in. It just could not happen. And so while we've learnt to overcome that kind of bigotry and religious division, we make the same mistakes again in relation to Islam, and we ascribe the sins of a few fundamentalists to the religion as a whole. So the wheel turns round. When are we going to learn from history? Perhaps the most important thing to try and learn is that if you are ever going to get to a solution, if you are ever going to create a peaceful world, you are going to have to ask: what is it possible for the other fellow to do— for your opponent to do? If you are going to stand up and preach at him and say you've got to do this, you've got to do that, there'll never be an agreement.

The desires that people have are similar—the basic values—whether it's an impoverished African village living in a tin shanty, or people living in equivalent, and I'm afraid equally primitive, circumstances in some Aboriginal settlement in Australia, the desires are the same. Treat people with respect. You can't send in somebody who's got a law degree and a social welfare degree of some

kind who thinks he knows all about how to advance somebody who's less fortunate, who'll go in and start saying, "This is what you must do," or, "That is what you must do." The first thing is to know how to treat that person with respect. Because if you don't, if you suggest that because of your education and wealth that you are in some way better, they'll sense it from a hundred yards away and then there'll never be communication. Because at core, at heart, they deserve respect and everyone, all of us, needs respect.

Compromise is a question of judgment—how far can you go without forgoing a matter of great principle? President Eisenhower and his successors were totally confident that they could speak to their counterparts in the Soviet Union and not compromise anything that was important to the United States or to the Free World. And they didn't. They were confident in themselves. They knew that to talk was not to compromise, to talk was not to endorse, to talk was to see if there is some area within our principles and our beliefs where we can agree, to try and make the world a less dangerous place. And until the current American president, that process was working well. It was working effectively. Even though the Soviet Union no longer existed, a number of agreements have been put in place which would make nuclear war, nuclear confrontation, much less likely. The presidents who participated in that process couldn't have done it if they were not confident in themselves, what they stood for; and couldn't have done it if they hadn't had very good advice along the way from great secretaries of state. But when you say you won't talk, it means you have no confidence in yourself or in what you stand for. You've got to force a public admission on the opponent. If you want to get to an agreement, you've got to assume that at some point you'll find agreements, and that an opponent can become a friend. In recent times, the United States has lost that sense of confidence. I'm very hopeful that it will regain it. If Australia does things badly we just harm ourselves, not much more than that. If America does things badly, it harms America and the entire world, and that's the burden that America has to carry as a wealthy and a very powerful, large country. But if you look at the good things that have happened in the last fifty, sixty years: the United Nations, the World Bank, the International Monetary Fund, the Universal Declaration of Human Rights, the conventions negotiated under it, the International Criminal Court which George Bush wouldn't sign on to…all would not have come into being if American lawyers and draftsmen hadn't helped draft the statutes to make sure that they were good and workable. Europe could have taken the lead in a lot of these issues, but Europe hasn't and I don't think Europe is going to. So, even though sometimes we can be disappointed, America remains the world's best hope for a free and open and peaceful society.

Edward M. Kennedy

For a career in public service, you have to work and develop knowledge about what you're most concerned about, what motivates you. You have to learn, and study, and work hard on that. That's enormously important. And then you have to try and work locally, try to make a difference in local communities. It may be in government, it may be in a non-profit, it may be in some other kind of organization. But working at the local level and meeting and working with people who are inspirational, in and of themselves, inspires you to work hard and to continue the pathway to a public life. I was able to take a shortcut because of the relationship with my brothers, but I worked hard in their campaigns and enjoy working hard. Every day I worked with them I was always inspired: they were making a difference and I could make a difference. You don't have to be a United States senator to make a difference. Nurses make a difference. Policemen make a difference. People who work with special needs children make a difference. Those are the positive forces in our life that make life worthwhile and worth living.

It takes compromise to make real progress. Congress is an institution that requires its members to work together to pass legislation. It's rare that one person alone can achieve the major things that are possible when many of us work together. You can't let the best be the enemy of the good. Over the years, I've been proud to work with my colleagues across the aisle on a range of issues. It's because of those relationships that many important, wide-ranging pieces of legislation are law today.

Anti-immigrant sentiment is a complex phenomenon. It typically increases in a time of economic downturn, and recedes when people feel their own futures are secure. It also recedes over time. I still remember my grandfather taking me on walks in downtown Boston and pointing out the job vacancy signs in store windows saying, "No Irish need apply." We've always been a nation of immigrants, and we always will be. It's contributed immensely to our nation and it still does. It's the essence of the American dream.

It takes compromise to make real progress.

Billie Jean King

You have to see it to be it.

Everyone should have their dream and be able to go for it; but I knew people probably wouldn't listen to me as much as a girl, so I had to become number one. I knew people would talk to me more. I'd get more done if I was number one. That was very important because that would give me a forum. When I started tennis, it was an amateur sport and we made fourteen dollars a day—when we were the big shots. I knew that tennis eventually had to be professional for me to feel that it had integrity. It's very important to keep people in their skilled area to make a living, and I had the passion to play tennis and that's where I needed to be and make a living. A few of us fought very hard to make tennis a professional sport and have prize money, and that finally happened in 1968. So we're off and running; but then it wasn't equal prize money, so it was another whole discussion: now we're going to have to worry about women getting more money, and we finally got equal prize money in the majors in 2007, but it took from 1968 to 2007.

You have to see it to be it. If girls don't see women become President of the United States, if they don't see a woman athlete being appreciated the same as a male athlete, if the media doesn't have fifty percent women—right now, ninety percent of the media's controlled by men—women have to see it to be it. Just like little boys have to see it to be it, both boys and girls deserve to dream big and go for it. It's very important to try to improve things. Poverty is seventy percent women, and that's why micro-financing is particularly important in Africa and Asia. This will be the century of women because of micro-financing. That is free enterprise at work, teamwork with teams of women, and Muhammad Yunus is one of my heroes because he started it. He started to give these little small loans. He gave them to men and women and the men didn't pay him back. So he said the heck with that, I'm just going to give to the women. The women pay back 99.6 percent. So that was a no-brainer.

The important thing is that women are the primary caretakers, and they have sons and daughters and this is the first generation of their sons and daughters that are going to university; and they didn't even have shelter, they didn't have clothes, they were going to bed hungry every night. And because these women created a job for themselves, whether it was the phone lady in the village, whether she got a weaving machine, or whatever she did, she now can take care of her own family. And what's the first thing she wants to do once she has all these things? She wants to start saving money. What's the second thing she wants? She wants health benefits. We're all the same, in the whole world. We all want the same things for our children and for our world.

When you're the dominant group you know very little about the sub-dominant groups. Sub-dominant groups know a lot about the dominant group. And that's why the establishment ignores basic human rights, because if you're the dominant, you're in power: things are good, I'm not going to rock the boat. But we always have a few people, even in the establishment, who notice and do care and change things over time. There's always people along the way that want to do the right thing, even if it isn't popular. It's very important. I have a mentor, Ed Woolard, who was the C.E.O. at DuPont. He didn't have to, but he brought in the green environment because he knows that they're a chemical company and they've got to do things that are going to make it right. He started it way before he had to. That's the kind of thing you want. You want people to take the initiative before they have to, before the law comes in and just tells you that you have to. That's what's really good, when people just take it upon themselves to do the right thing and keep thinking about it and also just talk amongst each other.

Juan José Linz

In a democracy, it's up to you to participate or not.

In a democracy, it's up to you to participate or not. One of the rights people fortunately have in a democracy is to not be interested in politics, to not care. That may be bad, but they have the freedom to do that. You can vote for candidates who have no chance, but you express your opinion, your preference. The democratic system is more in agreement with human nature and with our notion of freedom and independence than any other.

What's wrong with democracy? Democracy has many inherent defects. First of all, it assumes that there's one single solution to problems and all those other solutions are the wrong ones. Everyone who supports a solution thinks his is the right one and the other one is the wrong one. So, in some ways, half of the people will always be more or less discontent; but they have the chance four years later to convince those who supported one alternative to think it over, to come to their side and do it the other way around. That process, obviously,

leads to a considerable amount of unhappiness and a negative opinion about parties and politicians. It's a feeling that *they* do not represent *my* interests. There's a lot of ambiguity in that notion of "representing your interests," because the interests may be as a citizen living in a certain community which has a factory that is closing, or as a citizen of the whole country, or as a citizen in a world order. In a democracy, people can choose different points of reference and different ways of thinking, and that, obviously, is not the same thing as when you have a classical notion of national interests. In some ways, ethically, democracy creates an air of indifference to the outcomes, within a certain range.

The office of the President is overloaded with expectations. It's a combination of two things. On one side, it represents the whole country, the unity of the country, the symbol of the nation; on the other side, it represents a partisan role, and those two are in conflict. In some other systems, such as

parliamentary systems, you have a king or an elected president who represents a country when he travels and so forth, and then a prime minister; and that is not the case in the United States. The other thing is that the United States does not really have a professional bureaucracy of civil servants who are there permanently. In the United States, the president brings in his own new team. They have to have some experience in positions of power and so on, but you don't have a kind of permanent staff. It has to be created or recruited for each new president. So the president does not have an easy job. But governing is not an easy job and governing a country of the size and the complexity and the power of the United States is even more difficult. One assumes that a president must have courage, honesty, loyalty, intelligence, and the capacity to move people within the political class, but also the citizens. So that's partly rhetoric, partly personality, partly ideas. Then there's the capacity for work and daily management, and the ability to face a crisis.

What is amazing in a sense is how many regimes—totalitarian and some non-totalitarian too—exceed the need of repression and violence to keep governing. To be in power is not that difficult, even without an organized structure, if you have the loyalty of the armed forces and the police. Some of the regimes that have crumbled, like the Fascists in Italy and Nazi Germany, crumbled because they were defeated in war, not because the people rebelled. In Germany and the Soviet Union, rebellion was not possible. In the Soviet Union, they themselves decided that it didn't make sense to keep that system going as it was and tried to reform it. It's only when they tried to improve or correct the problems in a system that they got more opposition and more discontent.

Václav Havel

Totalitarian systems are unable to derive their policies from a diversity of ideas. What they all have in common is total subordination and devotion, either real or feigned. To control a population through fear is incompatible with human freedom. Art, on the other hand, is an expression of freedom of spirit—if it really is art. And that is something no despotism can permit.

Apart from what is intrinsic to all living beings, the most fundamental human needs are freedom and the search for the meaning of our existence, of everything that surrounds us and which we are part of.

Art becomes active as soon as it reaches the public. When I was a banned playwright, the only option was to record my plays onto tape. I mostly recorded them on my own, and they circulated in totalitarian Czechoslovakia in that form. Although it's an unusual solution, in the case of plays, one can easily rely on the listener's imagination.

Creation and destruction are two sides of the same coin. The whole of being is a conflict between creation and destruction, between life and death, and between being born and dying in the broadest sense of the word. The devastation of the landscape arouses existential angst within me because I perceive it as devastation of the human soul. My way of overcoming that angst has been to formulate my impressions, feelings, and ideas in literary works.

Ravi Shankar

Music transcends all barriers.

Kris Kristofferson

People have said if you take freedom out of my songs I'd be speechless.

Freedom was always something I was fighting for in my own personal life: the freedom to be who I thought I was supposed to be and to do what I thought I was supposed to do, and the respect for the freedom of everyone else to do the same. Whether it's working with Mandela, or for the Sandinistas, or against everything my government's doing today. It's a little disconcerting to realize that maybe the biggest threat to freedom in the world today is the government of my own country, and I'm hopeful that Barack Obama, who talks more like John Kennedy than anybody since Kennedy, will change this in the world. I think it's the most hopeful thing that's happened in American politics since the Kennedys. And he's the first person who's talked about finding common ground with other people, a dialogue with the Cubans, with Chávez in Venezuela. The best thing that could happen to the world would be his presidency. I hope that's going to happen.

I felt, when I was in the army, that I had a duty to serve my country, to stand up for the things I believed we were standing up for. It could be very disillusioning to find that what we were supposedly fighting for in Vietnam wasn't what we were fighting for in Vietnam, just as what we're supposed to be fighting for in Iraq today is not what they said we were doing. It was economics. It was money. What I took away from the military experience was a sense of responsibility, and it was probably that same sense of responsibility that made me come out against the wars and against our policies in Central America and Latin America and against what we're doing in Iraq today. I grew up before, during, and after the Second World War, and in those days I believed, and most people believed, that we stood for justice, human rights. It was inter-

esting that the commander-in-chief of the Allied forces during the Second World War, Dwight D. Eisenhower, when he left the presidency, warned against the growing power of the military-industrial complex. Which is what is running things today. It's so depressing to see the billions of dollars that are going into the war that could eliminate poverty, provide education and provide free health care for everybody in the United States. My God, we could alleviate all the poverty in Cuba and South America with just a fraction of what we're spending on the war.

It's encouraging to read that over eighty percent of Americans feel we're going in the wrong direction today. I don't know if just political change can affect that much in the world. It has to be on a direct, personal, and emotional level, where we feel a connection with every human being. It's a fairly daunting problem because we're talking about getting along with different religions like Muslims and Jews and Christians, and Christians can't even get along with each other, you know? The Irish and the English are still basically at odds with each other. The change has to be in the heart. That's where people who have a platform and an audience, like musicians, have a responsibility to change the heart, to address the heart. If you move people emotionally, then the head will follow. At any rate, that's the only option I have, because I'm not about to run for office. If you can touch people's hearts, you can make change.

The heart is what matters most of all. The act of compassion, of being able to put yourself in somebody else's shoes and to avoid any kind of harm to any other human being would be the best thing that could happen in the world.

Willie Nelson

Be here. Be present. Wherever you are, be there. And look around you and see what needs to be changed.

I was in the air force a while and they had what they call "policing the area." That's where you looked around and if there's anything wrong here, there, anywhere, you took care of your own area. And I think that's a pretty good thing to go by. If everyone just takes care of their own area then we won't have any problems.

Necessity is still the mother of invention, and if we start really needing energy, we'll get it. We have solar, we've got water, we've got all kinds of things that we can use, and eventually, if the circumstances get serious enough, which I really believe they will in the next few years, people will start realizing that there are alternative energies and you don't have to go around the world starting wars over oil. It can be grown here by our local producers. We don't have to transport our fuels from around the world. We save a lot of money. By doing that, we save the environment.

Once the federal government realizes how much revenue they're missing out on, they'll get into it. When I was in high school, when I was a future farmer of America, we made rope from hemp. And the government decided they would make it legal during the war. But once the war was over they made it illegal again, because they didn't need it. You have to regulate it, tax it.

It just so happens that oil is one of the government's biggest profits, and one of the biggest profits is war. And if you're in the financing business or in the bullet business you can start wars, finance both sides, and sell bullets to both sides. That's been going on for a long time.

Bryce Courtenay

Generosity overpowers greed.

You cannot oppress an individual; you can only oppress a society. And society is always rescued by an individual. Always. Mandela, Gandhi, it goes on and on and on and on. We are the sum total of the entire society, and we can decide whether we are going to be oppressed or not. I was born illegitimately in a very poor part of the country and I was put into a very, very nasty orphanage. The grandest ambition for any of the kids in that orphanage was they might be a railway fettler, or a guard, or work on a farm as a labourer running a gang of Africans. That was the height of ambition, but mostly they were going to turn out to be drunks. How come I didn't? Now, I had a cousin, he was also in the orphanage, and I was in Cape Town doing a book launch last year and I managed to trace him and I made an appointment to see him. Now, I'm staying in a five-star hotel, there's a limo picking me up, taking me to various events. I don't think anything about this because I'm being treated well, and I say, "Can you meet me at the hotel?" First of all I called his wife and she tells me in no uncertain terms to nick off, you know, using the "f" word, and I persist, I don't give up. And finally I get him and he says, "Ya, ya, okay, I'll come, I'll come around." And I arrived in a big stretch Merc or something, and there's a little guy and there's a huge Zulu doorman over there in his uniform and his top hat, wrestling with this little guy, trying to push him out. The little guy looks amazingly like me, except he's got no teeth, his nose is broken, and he's in rags. That's my cousin. I take him in and I said, "What do you want?" He says, "What do I want? Of course, I want a whiskey." He's a drunk and he just tries to get money from me; that's all he's interested in. Now: identical background. Same genes. Persistence or not,

that's all. At eleven I won a scholarship, then won another one to university overseas, only because I persisted. It wasn't because I was brilliant or clever or exceptional or a genius—any of those things— as a kid I had the crap kicked out of me and I kept getting up, that's all. You just have to keep getting up, dusting off your pants, and saying, "Here we go again." I was a boxer from the age of seven; it was the only way I could stay alive. The only reason I'm a storyteller today, seriously, is that while I learnt to box at the age of seven, I realized there was a much more powerful way to avoid having the crap kicked out of me: tell stories. I used to say, "Oh man, don't hit me, please don't hit me because I'll tell you a story. You bring all the fellows around and I'll tell them a story." And the guy would say, "If it isn't a good story, *ek sal jou*," which in Afrikaans means, "I'll beat the shit out of you." I'd tell them a story, but I'd never tell them the end. And I'd say, "Anybody who touches me before tomorrow doesn't hear the end of this thing." I thought, honestly, by the time I got to a posh boarding school and had my first pair of shoes, that I'd invented the serial. There wasn't a radio or anything like that and when I heard my first serial I thought, "They've pinched my idea, those buggers." But again it's persistence. Here I am at a school for millionaires' kids and I'm a good sportsperson and I've got half a brain, so I'm surviving. No pocket money or anything like that. Holidays come, I'd sleep in the benches in the park. I'd try to get a job so I can pay for my shirts or whatever I needed. Now, that sounds pathetic. It isn't. It's wonderful. It was absolutely wonderful, because it was life. And the generosity of twenty-seven bums who used to sleep in the park with me was extraordinary, absolutely extraordinary.

We are the sum tota

of the entire society.

Jimmy Little

My dad told me, "Son, there are three words that will open any door: the door of a building, the door of the mind, the door of the heart, any door you like. Three words, don't forget, always use them. 'Thank you' and 'please.' That's your calling card." So we learnt to respect the land and each other, and respect what a person can share and give.

Time changes, seasons change, the landscape changes, attitude changes and many other things change, but human nature is about survival, getting what you can out of life. If you're going to dig a hole and use that pile of dirt for something over here, you've got to fill that hole up with something else. You're going to replace it. There are people digging holes everywhere and ignoring it, and they're wondering why they're getting bad luck all over the place; they're not paying respect back to Mother Nature and Father Time. It's not about covering your tracks, but saying, "Thank you."

Jane Goodall

Children can change the world.

It's awfully sad that with our clever brains, capable of taking us to the moon and developing all these sophisticated ways of communicating around the planet, that we seem to have lost wisdom; and that's the wisdom of the indigenous people who would make a major decision based on how that decision would affect people seven generations ahead. We're making decisions based on the bottom line. How will this affect me now? Me and my family, now. How will this huge decision affect the next shareholders' meeting three months ahead? How will this decision I make today affect my election campaign? Something like that. So although we think we're caring about our children and grandchildren, we're actually stealing their future.

We've been very arrogant in assuming that there's this sharp line dividing us from the rest of the animal kingdom, and we need to realize that we are not the only beings on this planet with personalities, minds, and, above all, feelings and emotions. We need to be a little more respectful.

The very most important thing that we can do to try and get out of the mess we've made on this planet, both social and environmental, is to spend a little bit of time learning and thinking about the consequences of the choices we make each day. What did we eat? How was it grown? Where did it come from? Did it affect the environment adversely, or animal welfare? Is it good for human health? What do we wear? Where was it made? Does this involve child slave-labor or sweatshops? How do we get from A to B? Could we do it in a way that is less damaging to the environment? If we start to think like that, inevitably people make small changes, because very often they do things without having the faintest idea of the adverse consequences, and if people start making the small changes, then you start getting the major change that we must have if we care about the future for our children. Children can change the world.

I learned from my mother that fighting should only be allowed, is only moral, if you are absolutely sure you are fighting for the good things in humanity, if you are fighting without a power play. You can be wrong also. And if you are fighting and you are wrong, then this has nothing to do with Christianity or with believing in God. Then, you are inhuman.

Graham Nash

A lot of the world's troubles stem from lack of self-image: not being confident in who you are and what you're supposed to be doing in life. Wisdom could very well start with a little perspective. Let's understand a couple of basic things here. We're spinning around on a ball of mud that is one of billions and billions of balls of mud spinning through this universe, and the human life form is just one of perhaps many, many life forms throughout this universe. There's part of me that realizes that everything is completely meaningless, really. That if the last human being were to die in the next ten minutes, this Earth would still be spinning and it would rectify its growth pattern and human beings would be forgotten and the next life form would start, right? We need a little perspective about how unimportant what we do is. Having said that, I think it's very important to like yourself, it's important to love your family and love your friends and do things that help you grow and help you sleep. That's what I'm trying to do with my life.

With regards to the United States, we need to realize a couple of things. It was built on violence. It came from violence and it will continue in violence. I've often thought that it would be an interesting experiment to find the violence gene in the human genome and take it out and see what happens. Obviously there would be an enormous amount of problems with that theory. But this killing each other, especially in the name of God, is completely unholy to me. I don't understand the mind that says, "My God is better than your God, and I'm going to kill you to prove it." I don't understand that at all. I would like to live my life in peace. I'd like to live my life in harmony with my fellow human beings that inhabit this planet and I would just like an easy life. Now, obviously, the human condition makes it certain that it's not an easy life, but I try and follow my heart and I try and take the path that is right for me at that moment.

I don't understand the mind that says, "My God is better than your God, and I'm going to kill you to prove it."

Nelson Mandela

Peace is the greatest weapon for development that any people can have.

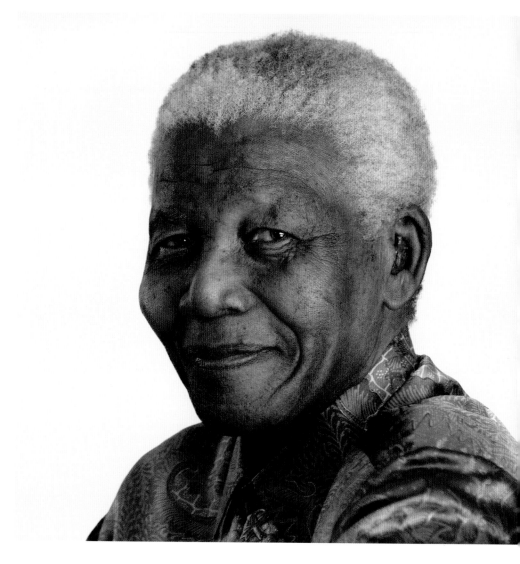

A good head and a good heart are always a formidable combination. There are few misfortunes in this world that you cannot turn into a personal triumph if you have the iron will and the necessary skill.

It is what we make out of what we have, not what we are given, that separates one person from another.

I learned that courage was not the absence of fear, but the triumph over it. I felt fear myself more times than I can remember, but I hid it behind a mask of boldness. The brave man is not he who does not feel afraid, but he who conquers fear.

Overcoming poverty is not a gesture of charity. It is an act of justice. It is the protection of a fundamental human right, the right to dignity and a decent life.

If the experience of South Africa means anything to the world at large, we hope that it is in having demonstrated that where people of goodwill get together and transcend their differences for the common good, peaceful and just solutions can be found even for those problems which seem most intractable.

I learned that to humiliate another person is to make him suffer an unnecessarily cruel fate.

Helen Suzman

I just try to draw the difference between right and wrong.

When I went to Robben Island, I was making use of, and I probably should have done it sooner than I did, my position as a Member of Parliament. There had been a lot of very unfavorable press reports about the treatment that political prisoners, like Nelson Mandela and Walter Sisulu and others, were getting on Robben Island. So I went to see the Minister of Justice and I said, "I want to go and pay a visit." And he said, "It's all nonsense, these reports". I said, "If you say so, no one will believe you. But if I go and I say so, then they may well believe me. But I must tell you, if you let me go and these accusations are correct, I'm going to say that too." It didn't require any courage. It required stamina. I was the only one to do it, to start with. But others followed suit as soon as they saw the publicity that this engendered.

I'm not a religious person, I'm a secular Jew. And I really don't go for religions of any kind. I was educated at school at a part-time convent, so I have some knowledge of the Catholic religion and I know a bit about the Anglican, Jewish, and Islamic traditions. And I reject them all. There were principles that I thought were very important. And as I matured, I realized it was very important to have freedom of speech, freedom of the press, an independent judiciary, and a proactive civil society. Those were the important things. I just try to draw the difference between right and wrong.

Michael Parkinson

I never thought since you're famous you should become a crusader. I mean, if you feel strongly about those issues you should use your celebrity wisely. The problem is you might bore the populists. I feel very strongly about certain things and I suppose I've been guilty of using my celebrity to actually further that cause and I don't think that's wrong. What I don't like are people who jump on a bandwagon who you damn well know aren't that concerned about whatever it might be but use it as a means for publicity. That's wrong, I think. I think people, as any human being should do, whether you're famous or not, should stand up for what you believe is right. I had a long fight in the sixties and seventies against apartheid and I was banned from going to South Africa, that sort of thing. I didn't do that because I was famous, it helped because I was famous and got the publicity, but I did it because I thought apartheid was wrong. I think that's the only thing you can do. I hate it when people jump on trendy bandwagons. I don't like that at all. I think a lot of people are guilty, particularly in the media, of using the environment as propaganda, if you will. I'm concerned about it, but I'm from a generation that is concerned about other things as well. Maybe if I were a younger man I would be much more concerned than I am about it. I've got my share of concerns; my box is full.

Richard Rogers

I am extremely fortunate in that architecture has brought me great joy throughout my life. The biggest change over the fifty years that I have worked as an architect has been the increasing impact of environmental concerns on projects and the way in which they influence the design of buildings.

Our buildings were once simple geometric cubes; however they are now becoming far more responsive to their natural environment, capturing the sun, harnessing the wind, and taking heat and water from the earth and rain from the clouds.

The most critical challenge for the future of architecture is environmental sustainability and the impact of climate change. We can't be sure how close we are to the "tipping point"; yet it would be a tremendous sadness to see civilization destroy itself when it can implement relatively simple shifts in behavior which will reverse the trend towards self-destruction.

One of the roles of the architect is to participate in this debate. Cities—the buildings that make them up and the infrastructure that serves them—consume more than three-quarters of all the world's energy; architects can help to reduce this consumption significantly by creating buildings and support services which are at least fifty percent more efficient in energy terms than at present.

There is a direct relationship between the quality of the environment in which we live and the quality of our own lives. If you happen to be fortunate and live in a vital city where you can readily find food and employment and have access to attractive spaces, you naturally derive greater joy from being there. If you are unfortunate enough to be brought up in an horrific slum and live in great poverty with few opportunities to improve your own environment, you are likely to struggle.

Everybody living in a city should be able to see a tree from their own window; they should be able to sit on their own "stoop" or have access to a roof terrace; they should have no trouble finding a bench in a public space to sit on, or finding a place for their children to play no more than a few minutes from their home. These should all be basic human rights.

You get form for your architecture from the community that it serves—and not the other way round.

For the past thirty years, I have been developing the concept of the compact, multi-centered city where walking, cycling, and public transport are encouraged, where people live near to the place they work, where the poor and the rich exist in close proximity, and justice is the right of every individual. This approach has formed the basis for the Labour government's urban strategy in the UK during the last decade, as well as the policy of the last Mayor of London, Ken Livingstone.

Cities are the most complex and socially-critical form of organization that mankind has created. Look at Athens around the time when the Parthenon was built. This was the city which was the catalyst for an amazing period in history, when civilization really took a leap forward. Whether in science or the arts, immensely wise decisions were made by the government and people of Athens which—in a sense—we're still building on today. One might say that although we build the cities, it is the cities that shape us.

The team I work with today at my practice, Rogers Stirk Harbour + Partners, has developed a "language" of architecture based on a number of key drivers including "transparency," "lightness," "flexibility," "movement," "sense of place," "environmentally responsible," "democracy," "process of construction," and so on. We celebrate these drivers in our architecture; for example, we celebrate the process of construction by making it highly visible, or we celebrate movement by putting the lifts and stairs on the outside of our buildings. My team communicates using this vocabulary. And, as language is about giving order to the way we communicate as human beings, architecture is about giving order to space. It's about the play of light and shadow on mass. I am fascinated by playing—aesthetically—with all these elements.

Ultimately, architecture has to be responsible to society. I like cities because of that word with which they are inexorably linked, "citizenship." Architecture is about people, first and foremost.

I'm still actively engaged in the struggle for social justice because I'm not dead yet.

There's this notion in the Church I grew up in about being born again, and so when you come into the Church you actually step into another version of yourself. I was eleven when I joined the Church. When I was in college, I was arrested in Albany, Georgia, for fighting racism in this country, and that really was a new birth for me. There's a song that says, "I look at my hands, my hands looked new; I opened my mouth, I had a new talk; I started to walk, I had a new walk." Everything was new, and I consciously have tried to keep that taste in my mouth—keep that taste in my life—and always be on the challenging edge of saying, "We can do better, and if you are a social citizen you are responsible for the condition you find yourself in and you have to find a way to comment on that." Either it's all right or it needs to be stopped. Your action in your life is a running commentary on what you understand about where you are; and that's not just yourself personally, that is any space you move through. Any system you are part of, you are supporting. So if that system is out of balance, then it's not outside of you being out of balance—it's not those people over there—you in some way helped that system to be what it is and you either are talking to that system and saying this is good, I like this, or this is absolutely insane and it needs to be changed. I don't think I'll ever not be that kind of being.

I don't really think music brings about social change. People bring about social change, and if they are from a music culture it is reflected in what they are doing musically. If they have music as a vital part of their culture, then music supports and echoes and feeds what they are doing.

I think of myself as a grain of sand. You can make a difference. Have you ever walked around with a grain of sand in your shoe? It's not comfortable. What I do is that small, but I do think I have to give it away and I have to give it away beyond my existence. It doesn't mean that where I am now does not matter. I enjoy this being alive, I enjoy organizing and addressing and speaking to issues. But my actions are insignificant unless I can find ways to throw my energy force so that it's passed to the future, and that means I have to do more than speak to my peers, I have to always be speaking to those who are younger than me and I have to always be dealing with technology, so that the unborn might actually stumble upon something that I have contributed that might be of some use. We are in a culture where you do a demonstration and you get locked up and the lunch counter is still segregated. Everybody in this culture says you failed. But you are totally transformed. You know you have not failed; you just haven't integrated the lunch counter. But in fact you have won. We are in a culture that asks for that quick assessment. I have students sometimes that say, "I like hearing Harriet Tubman better than Sojourner Truth." And I say, "They're both dead and you can have them both. Why are you going to pick one?" So when I think about having an impact, I think about getting up in the morning and going for broke in the space in which I'm conscious, and when I sleep it's fine and if I die in the next moment it's fine. All you have to do in your life is go for broke. People might actually discuss whether you made a difference at all, but you, as that grain of sand, have done what you were called to do by that part of the universe that never ends. Hopefully.

The Civil Rights Movement I call a "borning" struggle for our time. It brought into a contemporary period a reminder that you don't have to be rich and you don't have to be an army; but if you find yourself in a situation that needs to be changed, if you're willing to offer your life for it, you might actually get something done.

Wole Soyinka

A human being has a need for dignity.

Art on stage is a certain level of activity, but art translated onto society becomes very dangerously active. If you succeed in confining art to galleries, to the stage, to the concert hall, of course it's active, but that's a primary level of activity. A secondary level, when art becomes part and parcel of society, now that is a dangerous one. Art's ultimate mission is to affect people in some form or another. Otherwise one is indulging in a monologue, and very few monologues are really very active.

Art represents freedom. Power is control and denial of freedom. Governments very often have a sense that they're not defined unless they exercise maximum power. And art is so free, constantly interpreting society and phenomena in ways that cannot be controlled.

When I was in prison, one of the most important things I learned was the art of improvisation. You have to improvise your own world, you have to people it with insubstantial personages…the essence of it all is simply the possibility, the potential for recovering certain parts of one's knowledge in order to contest the brutality of existence.

There are so many societies in the world where people are actually content to live under fear. The definition of being a human being rests very much on the platform of dignity. Dignity. And any creature under fear is an undignified entity. A human being has a need for dignity, just like water, like air. People will say food, some people will say air, and my attitude is the most fundamental human need is dignity. The sense of being in control of one's existence. Ultimately, without food or water, you know, one dies, and then, okay, one can have a dignified death. Therefore, ultimately, you cannot control people by fear, because their ultimate essence is constantly craving for that property, that acquisition, called dignity. The fear clenching the subdued subhuman entity rebels sooner or later, because it's a need; it's a need for self-realization.

Vanessa Redgrave

The most important thing to treasure, to be defended and advocated and followed, scrupulously, is international human rights law, as being the highest law there is to date, superseding sovereignty.

People who work for human rights are the most valuable, and you have to be a hero to do that anywhere. I feel very lucky that I know some of those people, like Desmond Tutu. But it is quite horrifying to see how many of the practices of the KGB are being employed today by the United States administration and Britain, my country, to mention a few. And since I know the families and some of the men who've been in Guantanamo, one of the secret prisons where human rights have been abolished in the most terrifying way, I'm not sure what we can take away except to say that we've got to work for human rights laws. You go back to Joan of Arc, she was shown the instruments of torture, as they were called, one of which was the waterboard—which is referred to by the *New York Times* as "simulated drowning." I'm sorry, it *is* drowning, but the person is pulled back at the last minute from the brink of being drowned. It makes me very frightened, because one of the things that obsessed me as a very young teenager, eleven, twelve, thirteen, that kind of age, was how can it be that human beings can become changed? I was thinking of Germany, because I knew that Germany was a very advanced, progressive country and suddenly over the space of a few years the Nazis took power. How does the mind of people change so they can accept something?

Biographies

Chinua Achebe
16 November 1930
Ogidi, Gongola
Nigeria

Educated at the University of Ibadan, Chinua Achebe began his career with the Nigerian Broadcasting Corporation in 1954. In 1958 he published his first novel, *Things Fall Apart,* which was subsequently translated into over forty languages with sales in excess of eight million copies. With his focus on the clash between traditional culture and Western values, Achebe has become a major voice for African literature. He has written novels, poetry, short stories, children's books, and essay collections. Achebe was awarded the Commonwealth Poetry Prize in 1972 and the Man Booker International Prize for Fiction in 2007.

Madeleine Albright
15 May 1937
Prague
Czech Republic

Madeleine Albright's family fled Nazi persecution in 1939, first to England and then to the USA, where she earned several degrees in international affairs, including a Ph.D. Albright worked on the Muskie presidential campaign in 1972, and later became a staff member of both the National Security Council and the White House. During the Republican administrations of the 1980s and early 1990s she lectured in international affairs at Georgetown University. In 1992, President Clinton appointed her UN Ambassador and five years later she became the first female US Secretary of State (1997–2001). She is a co-founder of the Center for National Policy.

Alan Arkin
26 March 1934
New York, New York
USA

Alan Arkin formed the folk group The Tarriers after dropping out of college, and co-wrote "The Banana Boat Song," which would later become a hit for Harry Belafonte. His screen debut came in 1957, followed by roles on and off Broadway, and he won a Tony Award in 1963 for *Enter Laughing.* Arkin's role in *The Russians Are Coming* earned him the first of three Academy Award nominations. In 2006 Arkin won an Academy Award for his role in the film *Little Miss Sunshine.* He has written numerous songs, as well as science fiction and children's books.

Frederik Bolkestein
4 April 1933
Amsterdam, North Holland
The Netherlands

Frederik Bolkestein received his Bachelor of Science from the London School of Economics in 1963, and his Master of Laws degree from Leiden University in 1965. Bolkestein worked for Royal Dutch Shell for fifteen years before entering Dutch politics. He served as the European Commissioner for the internal market, taxation, and the customs union from 1999 to 2004, where he spearheaded what is now known as the "Bolkestein Directive," aimed at creating a single market for service in the European Union.

Dave Brubeck
6 December 1920
Concord, California
USA

Dave Brubeck studied music at the University of the Pacific. He graduated in 1942 before serving in the US Army. After World War Two he continued his studies at Mills College under Darius Milhaud, who encouraged him to play jazz. In 1951, he formed the Dave Brubeck Quartet and released albums such as *Jazz Goes to College*. Brubeck's music is notable for unusual time signatures and his 1959 album *Time Out* included "Take Five" set in 5/4 time, which has become a jazz standard. He received a Grammy Lifetime Achievement Award in 1996.

Zbigniew Brzezinski
28 March 1928
Warsaw
Poland

The son of a Polish diplomat, Zbigniew Brzezinski obtained an MA from McGill University before moving to the USA where he gained a Ph.D. at Harvard University. He taught at the Russian Research Center and Columbia University before becoming an advisor to the Kennedy, Johnson, and Carter presidential campaigns. Brzezinski rose to the position of National Security Advisor in the Carter Administration (1977–1981), and later advised presidents Reagan and Bush, Sr. on foreign policy.

Bryce Courtenay
14 August 1933
Johannesburg, Gauteng
South Africa

A naturalized Australian, Bryce Courtenay's early years, before boarding school, were spent in a village in the Lebombo Mountains of South Africa. He later won a British university scholarship but was banned from returning to South Africa as a result of "politically unacceptable activity." Courtenay emigrated to Australia in the late 1950s and worked in advertising before taking up writing at the age of fifty-five. His first book, *The Power of One,* became an enduring bestseller. He has subsequently written over twenty books and remains one of Australia's most successful authors.

Clint Eastwood
31 May 1930
San Francisco, California
USA

Clint Eastwood first found fame in 1959 in the television series *Rawhide.* He gained international stardom as a hired gun in the "spaghetti" Western *A Fistful of Dollars* (1964) and its sequels *For a Few Dollars More* and *The Good, the Bad and the Ugly.* Eastwood also starred in non-Westerns, such as 1971's *Dirty Harry*; a year that also saw his directorial debut with the thriller *Play Misty for Me.* He has continued to direct, and star in, a variety of movies, winning five Academy Awards as well as the Irving G. Thalberg Award for lifetime achievement in film production. In 2007, Eastwood was awarded the National Order of the Legion of Honour (France).

Garret FitzGerald
9 February 1926
Dublin
Ireland

Garret FitzGerald was one of the Republic of Ireland's most popular politicians and was its Taoiseach (prime minister) twice, from July 1981 – February 1982 and again from December 1982 – March 1987. He obtained a BA and Ph.D. from University College Dublin and entered the Irish Senate in 1965 and the House of Representatives in 1969. In 1973, FitzGerald became Minister for Foreign Affairs and when his party, Fine Gael, was defeated in 1977 he became leader and led a minority coalition government in 1981. He resigned as party leader after the 1987 election defeat, and retired in 1992.

Malcolm Fraser
21 May 1930
Melbourne, Victoria
Australia

Malcolm Fraser attended
Melbourne Grammar School
and the University of Oxford.
He returned to Australia to enter
politics and won the seat of
Wannon in Victoria for the Liberal
Party at the age of twenty-four.
Fraser was appointed Minister
for the Army in 1966, and was an
outspoken advocate of both
conscription and the Vietnam War.
He later served as Minister for
Education and Science and
Minister of Defense. Fraser was
elected leader of the Liberal Party
in 1975 and became Prime
Minister the same year, a position
he held for three consecutive
terms. He received the Human
Rights Medal (Australia) in 2000.

Jane Goodall
3 April 1934
London
England

Regarded as one of the world's
authorities on chimpanzees, and
the only human ever accepted
into chimpanzee society, Jane
Goodall began work as a
secretary and film production
assistant before traveling to
Kenya, where she met
anthropologist Louis Leakey,
who helped her establish the
Gombe Reserve project to study
chimpanzees in the wild. She
pioneered the study of
chimpanzee behavior and
society in the wild, observing
that chimpanzees are
omnivorous, make tools and
weapons, and have a primitive
"language" system. A renowned
conservationist, Goodall has
published numerous articles and
books, and in 2003 was awarded
a DBE (Dame Commander of
the British Empire).

Nadine Gordimer
20 November 1923
Springs, Gauteng
South Africa

Nadine Gordimer published her
first short story at the age of
fifteen and went on to complete
fourteen novels, nineteen short-
story collections, several works
of non-fiction, and a number of
television scripts based on her
works. Her writings center on the
effects of apartheid, of which she
was a passionate opponent, and
have been translated into forty
languages even though many of
them were banned in South
Africa. In 1974, Gordimer won the
Booker Prize for Fiction for *The
Conservationist.* She was
awarded the Nobel Prize for
Literature in 1991, and in 2007
became a Knight of the National
Order of the Legion of Honour
(France).

Václav Havel
5 October 1936
Prague
Czech Republic

Because he was born into a
bourgeois family, Václav Havel
was barred from post-secondary
education in Communist
Czechoslovakia. He worked in
theater and became a playwright,
satirizing his country's totalitarian
regime, which led to numerous
imprisonments. In 1989, he
became a leader of Civic Forum, a
coalition struggling for democratic
reform, and when the Communist
regime capitulated, Havel became
the first non-Communist president
since 1948. The Federation
dissolved in 1992 and he was
elected first President of the new
Czech Republic, serving from
1993–2003. In 2003, Havel was
awarded the Gandhi Peace Prize.

John Hume
18 January 1937
Derry, County Londonderry
Northern Ireland

John Hume originally studied for
the priesthood before becoming
a teacher. He was elected to the
Northern Irish Parliament in 1969.
A founding member of the Social
Democratic and Labour Party,
Hume was appointed leader in
1979 and elected to the European
Parliament. In the mid-1980s, he
initiated private talks with Gerry
Adams, leader of Sinn Fein, which
ultimately resulted in the 1998
Good Friday Agreement. As co-
recipient of the 1998 Nobel Peace
Prize, the Gandhi Peace Prize
(2001), and the Martin Luther
King Award (1999), Hume is the
only recipient of the three major
peace awards.

Edward M. Kennedy
22 February 1932
Boston, Massachusetts
USA

The youngest of eight siblings,
including former President John F.
Kennedy and Senator Robert F.
Kennedy was educated at Harvard
University, the International Law
School (The Hague), and
University of Virginia Law School.
In 1962, he was elected senator
for Massachusetts and is currently
the second-longest-serving
senator in the USA. He is a
prominent advocate for social
policies such as national health
insurance, consumer protection,
and social welfare.

Billie Jean King
22 November 1943
Long Beach, California
USA

Billie Jean King won twelve Grand Slam singles titles, sixteen Grand Slam women's doubles titles, and eleven Grand Slam mixed doubles titles over the course of her career. The tennis match for which she is best remembered is the "Battle of the Sexes" in 1973, in which she defeated former Wimbledon men's champion, Bobby Riggs. The same year she founded the Women's Tennis Association. King has been inducted into the Women's Sports Hall of Fame (1980), the International Tennis Hall of Fame (1987), and the National Women's Hall of Fame (1990).

Kris Kristofferson
22 June 1936
Brownsville, Texas
USA

Kris Kristofferson won a Rhodes scholarship to the University of Oxford, and then served in the US Army as a helicopter pilot, eventually resigning to take up country music in Nashville. His compositions have been performed by over four hundred and fifty artists and he has recorded twenty-four albums. In 1971, he won a Grammy for "Help Me Make It Through the Night." He has also had a long screen career, with over one hundred film and television appearances including *A Star is Born* (1976), which earned him a Golden Globe for Best Actor. He was inducted into the Country Music Hall of Fame in 2004.

Juan José Linz
24 December 1926
Bonn, North Rhine-Westphalia
Germany

Juan José Linz was raised in Spain and gained degrees in economics, political science, and law at the University of Madrid. His studies on democracy and dictatorships, and their effects on a society, have made Linz a leader in the school of sociology. His seminal work, *Totalitarian and Authoritarian Regimes*, was published in 2000. Linz is presently Sterling Professor Emeritus of Political and Social Science at Yale University. He is also an honorary member of the Scientific Council at the Juan March Institute.

Jimmy Little
1937
Cummeragunga, New South Wales
Australia

After leaving school at the age of fifteen, Australian aboriginal Jimmy Little drew on his family background in music to launch his career. He made his radio debut as a teenager and toured with the Grand Ole Opry out of Nashville, Tennessee, in 1957. His first Australian hit came in 1959 with "Danny Boy," followed by many others including "Royal Telephone" in 1963. Along with a successful music career, Little has appeared in film and on television as well as teaching and mentoring Aboriginal people, a role which has earned him the moniker "Father of Reconciliation." He was awarded the Order of Australia in 2004.

Nelson Mandela
18 July 1918
Mvezo, Eastern Cape
(formerly in the Transkei)
South Africa

Nelson Mandela qualified in law in 1942 and two years later joined the African National Congress (ANC). Anti-discrimination activities led to his arrest for treason in 1956, although he was acquitted in 1961 before being rearrested in 1962. While still incarcerated, he stood trial with other ANC leaders for plotting to overthrow the government and was sentenced to life imprisonment, a term he served mainly on Robben Island. His reputation grew during his twenty-seven-year-long imprisonment, and after his release in 1990 he worked tirelessly to create a new multiracial South Africa. In 1993 he shared the Nobel Peace Prize with F.W. de Klerk, and the following year became South Africa's first democratically elected President (1994–1999).

Kurt Masur
18 July 1927
Brieg, Silesia
Poland
(formerly in Germany)

Conductor Kurt Masur studied piano and cello in Breslau, and then moved to the Leipzig Conservatory to study piano, conducting, and composition. Masur has directed orchestras around the world, notably the New York Philharmonic, the Orchestre National de France, the Leipzig Gewandhaus Orchestra, the London Philharmonic and the Israel Philharmonic. He has made more than one hundred recordings and received numerous honors including the Cross with Star of the Order of Merits (Germany, 1995), the Gold Medal of Honor for Music (National Arts Club, USA, 1996), Commander of the National Order of the Legion of Honour (France, 1997), and the Commander Cross of Merit (Poland,1999).

Graham Nash
2 February 1942
Blackpool, Lancashire
England

Musician and photographer
Graham Nash co-founded The
Hollies in 1961, one of the UK's
most successful groups whose
hits included "On a Carousel." In
1968, he moved to the USA and
formed Crosby, Stills & Nash,
whose first release was the hit
"Marrakesh Express," written by
Nash. In 1969, they performed at
Woodstock, the same year their
first album won a Grammy Award.
In 1990, he co-founded Nash
Editions, a digital printmaking
company, which was recognized
in 2005 by the Smithsonian
Institution for its role in the
invention of digital fine art printing.

Willie Nelson
30 April 1933
Abbott, Texas
USA

American country music star
Willie Nelson wrote his first song
at the age of seven and was
playing in a local band by the age
of nine. After stints as a DJ and in
the air force, his song "Crazy,"
recorded by Patsy Cline, reached
number one in 1961. His
breakthrough as a performer did
not come until the following
decade with alternative country
albums such as *Red Headed
Stranger* (1975), featuring the hit
"Blue Eyes Crying in the Rain,"
which won him one of ten
Grammy awards. Nelson has also
had many television and film
roles, and is a well-known social
activist, working among other
things to promote biofuels and
the decriminalization of marijuana.

Rupert Neudeck
14 May 1939
Gdańsk, Pomorskie
(formerly Free City of Danzig)
Poland

Neudeck lived in Danzig until his
family had to flee the city after
World War Two, when it came
under Polish rule. He attended
college in West Germany, and
later worked as a correspondent
for a German radio station. In
1978 he founded Cap Anamur, an
organization focused on helping
refugees from countries in turmoil.
More recently, Neudeck founded
Gruenhelme (Green Helmets),
which reconstructs villages in
destroyed regions.

Nick Nolte
8 February 1941
Omaha, Nebraska
USA

Nick Nolte attended Arizona
State University on a football
scholarship but dropped out to
become an actor at the Pasadena
Playhouse. He studied at Stella
Adler Academy in Los Angeles
and traveled for several years,
performing in regional theaters.
A breakthrough role in the 1976
television series *Rich Man, Poor
Man* earned Nolte an Emmy
Award nomination, and since then
he has played a wide variety of
characters in more than fifty films,
earning two Academy Award
nominations and winning a
Golden Globe, as well as a New
York Film Critics Circle Award for
Best Actor.

Yoko Ono
18 February1933
Tokyo, Kanto
Japan

Yoko Ono moved to New York at
the age of eighteen and gained
notoriety when she opened the
Chambers Street Series in her
loft, where she presented some
of her earliest conceptual and
performance artwork. In 1966,
Ono met John Lennon and they
started their highly publicized
relationship. Ono continues
to create performance and
abstract pieces. Her recent work,
Sky Ladders, was unveiled at
the 2008 Liverpool Biennial.

Michael Parkinson
28 March 1935
Cudworth, South Yorkshire
England

Michael Parkinson has interviewed
over two thousand people on his
eponymous show. He began his
career as a journalist before
moving into television current
affairs. In 1971, he began hosting
Parkinson, which ran until 2007,
interviewing guests as diverse as
Muhammad Ali and Miss Piggy. He
was awarded a CBE (Commander
of the British Empire) for services
to broadcasting in 2000, and in
2008 was made a Knight Bachelor.

Bernice Johnson Reagon
4 October 1942
Albany, Georgia
USA

While a student at Albany State College, Bernice Johnson Reagon was arrested for demonstrating and spent a night in jail singing songs, which inspired her to use music as a tool for activism. In 1973, she founded Sweet Honey in the Rock, an award-winning a cappella quintet performing traditional African and African-American music. From 1974–1993 Reagon worked as a curator for the Smithsonian Institute and she was a professor of history at American University from 1993–2002. She was awarded the Charles Frankel Prize in 1995 by President Clinton.

Vanessa Redgrave
30 January 1937
London
England

Vanessa Redgrave trained at the Central School of Speech and Drama. She joined the Royal Shakespeare Company in the 1960s, by which time she had already made her film debut and appeared on stage in the West End. She is the recipient of numerous awards, including two Golden Globes and an Academy Award, and in 1967 was awarded a CBE (Commander of the British Empire). Redgrave has supported a number of humanitarian causes since the 1960s and now serves as a UNICEF Goodwill Ambassador.

Richard Rogers
23 July 1933
Florence, Tuscany
Italy

Born to British parents, Richard Rogers studied at the Architectural Association in London and Yale School of Architecture. From 1970–1977 he worked with Italian architect Renzo Piano to create the Pompidou Centre in Paris. His other buildings include the Lloyds building in London (1984), the European Court of Human Rights in Strasburg (1984), the Daimler Chrysler building in Berlin (1999), the Millennium Dome in Greenwich (1999), and Heathrow's Terminal 5 (2008), and he has been chosen as the architect of Tower 3 of the new World Trade Center in New York City. In 1991, Rogers was awarded a KBE (Knight Commander of the British Empire), in 1996 he was made a life peer, and in 2008 he was awarded the Order of the Companions of Honour.

Ravi Shankar
7 April 1920
Varanasi, Uttar Pradesh
India

Ravi Shankar is one of the leading Indian musicians of the modern era. A legend in India and abroad, Shankar has melded Indian music into Western forms: he has written concertos, ballets, and film scores. In the 1960s, Shankar attracted worldwide attention for appearing at the Monterey Pop Festival and Woodstock, and for teaching Beatle George Harrison to play the sitar. His film score for *Gandhi* earned him nominations for both Academy and Grammy awards, and he has received twelve honorary doctorates as well as the Bharat Ratna, India's highest civilian honor. In 1986, he became a member of the Rajya Sabha, India's Upper House of Parliament.

Wole Soyinka
13 July 1934
Abeokuta, Ogun
Nigeria

The first African recipient of the Nobel Prize for Literature (1986), Wole Soyinka studied at Government College, Ibadan, and the University of Leeds. Radical themes within his writings led to clashes with the Nigerian government: in 1967, an article on Biafra led to twenty-two months' imprisonment, and in 1994, Soyinka went into voluntary exile after being charged with treason. He was sentenced to death in his absence, but a change of government enabled his return in 1999. Soyinka has published over twenty works, including plays, novels, memoirs, and poetry.

Helen Suzman
7 November 1917 – 1 January 2009
Germiston, Transvaal
South Africa

An implacable opponent of apartheid, Helen Suzman studied at Witwatersrand University where she also lectured in Economic History from 1944–1952. She exchanged academia for politics in 1953, becoming the only Member of Parliament opposed to apartheid. She spent thirty-six years in parliament, fighting apartheid as well as working for women's rights, and intervening on behalf of political prisoners including Nelson Mandela. In 1978, she received the United Nations Human Rights Award.

Desmond Tutu
7 October 1931
Klerksdorp, Transvaal
South Africa

Desmond Mpilo Tutu, Archbishop
Emeritus, began his career as a
teacher before studying theology,
and was ordained as an Anglican
priest in 1960. In 1975, he became
the first black Dean of St Mary's
Cathedral in Johannesburg,
followed by appointments as
the Bishop of Lesotho, General
Secretary of the South African
Council of Churches, Anglican
Archbishop of Cape Town, and
Primate of the Church of the
Province of South Africa. He
gained international fame as an
anti-apartheid activist in the 1980s
and was awarded the Nobel
Peace Prize in 1984 and the
Gandhi Peace Prize in 2007.

Federico Mayor Zaragoza
1934
Barcelona, Catalonia
Spain

Federico Mayor Zaragoza began
his career as a biochemist after
he obtained a doctorate in
pharmacy from the Complutense
University of Madrid in 1958. In
1974, he co-founded the Severo
Ochoa Centre of Molecular
Biology at the Autonomous
University of Madrid. After many
years spent in politics, Mayor
became Director-General of
UNESCO in 1987, a post he held
until 1999, when he created the
Foundation for a Culture of Peace,
of which he is now the president.
In addition to numerous scientific
publications, Mayor has published
four collections of poems and
several books of essays.

ISBN 978-0-8109-8442-4 (U.S./Canada)
ISBN 978-0-8109-8475-2 (U.K.)

Produced and originated by PQ Blackwell Limited
116 Symonds Street, Auckland, New Zealand
www.pqblackwell.com

Printed and bound in China

10 9 8 7 6 5 4 3 2 1

Abrams books are available at special discounts when purchased
in quantity for premiums and promotions as well as fundraising
or educational use. Special editions can also be created to speci-
fication. For details, contact specialmarkets@abramsbooks.com
or the address below.

THE ART OF BOOKS SINCE 1949

115 West 18th Street
New York, NY 10011
www.abramsbooks.com

The publisher is grateful to the Nelson Mandela Foundation for
permission to reproduce Nelson Mandela's images and words
on pp. 114–118 and 146. "Peace is the greatest weapon for
development that any people can have" from a public rally,
Tanzania, November 1988. "A good head and a good heart are
always a formidable combination. There are few misfortunes in
this world that you cannot turn into a personal triumph if you have
the iron will and the necessary skill" from *Higher Than Hope* by
Fatima Meer. "It is what we make out of what we have, not what
we are given, that separates one person from another"; "I learned
that courage was not the absence of fear but the triumph over it.
I felt fear myself more times than I can remember, but I hid it
behind a mask of boldness. The brave man is not he who does
not feel afraid, but he who conquers fear"; "I learned that to
humiliate another person is to make him suffer an unnecessarily
cruel fate" from *Long Walk to Freedom* by Nelson R. Mandela.
"Overcoming poverty is not a gesture of charity. It is an act of
justice. It is the protection of a fundamental human right, the right
to dignity and a decent life" from Live 8 speech, Mary Fitzgerald
Square, Johannesburg, July 2005. "If the experience of South
Africa means anything to the world at large, we hope that it is in
having demonstrated that where people of goodwill get together
and transcend their differences for the common good, peaceful
and just solutions can be found even for those problems which
seem most intractable" from address to the closing session of
50th ANC National Conference, December 1997.

Five percent of the originating publisher's revenue from the sale
of this book will be donated to a *Wisdom* royalty pool that will be
distributed evenly among charities nominated by the individuals
that appear in the book.